*L*OOKING AT *P*AINTINGS

Self-portraits

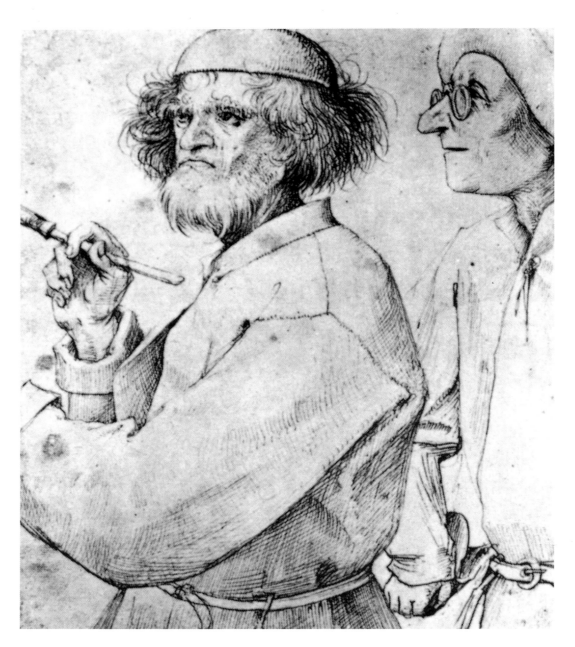

The Painter and the Critic, date unknown
Pieter Brueghel, Flemish (1525/30–69)

LOOKING AT PAINTINGS

Self-portraits

Peggy Roalf

Series Editor
Jacques Lowe

Design
Joseph Guglietti and Steve Kalalian

Hyperion Books for Children
New York

A
JACQUES LOWE
VISUAL ARTS PROJECTS
BOOK

Text © 1993 by Jacques Lowe Visual Arts Projects Inc.
A Jacques Lowe Visual Arts Projects Book

Printed in Italy

FIRST EDITION

1 3 5 7 9 10 8 6 4 2

Library of Congress Catalog Number: 92-72042

ISBN 1-56282-356-6 (trade)/1-56292-357-4 (lib. bdg.)

Original design concept by Amy Hill

Contents

Introduction 7

PORTRAIT OF THE ARTIST HOLDING A THISTLE
Albrecht Dürer 8

SELF-PORTRAIT
Leonardo da Vinci 10

PORTRAIT OF A YOUNG MAN
Agnolo Bronzino 12

SELF-PORTRAIT
Rembrandt Harmenz van Rijn 14

THE ART OF PAINTING
Jan Vermeer 16

SELF-PORTRAIT WITH TWO PUPILS
Adélaïde Labille-Guiard 18

MOTHER ANTONY'S TAVERN
Pierre-Auguste Renoir 20

SELF-PORTRAIT IN A FLOWERED HAT
James Ensor 22

SELF-PORTRAIT WITH STRAW HAT
Vincent van Gogh 24

SELF-PORTRAIT WITH A PALETTE
Pablo Picasso 26

SELF-PORTRAIT
Otto Dix 28

DOUBLE PORTRAIT WITH WINE GLASS
Marc Chagall 30

WHERE FRIENDS MEET
Max Ernst 32

SELF-PORTRAIT IN TUXEDO
Max Beckmann 34

THE ARTIST AND HIS MOTHER
Arshile Gorky 36

SELF-PORTRAIT WITH A BEER STEIN
Philip Evergood 38

SELF-PORTRAIT WITH MONKEY
Frida Kahlo 40

THE STUDIO
Jacob Lawrence 42

WE ARE ALL LIGHT AND ENERGY
Audrey Flack 44

Glossary and Index 46

Credits 48

In memory of my father, David Nathaniel Roalf

Introduction

LOOKING AT PAINTINGS is a series of books about the artistic process of seeing, thinking, and painting. Painters have created self-portraits for many different reasons. For most artists, the face in the mirror is the most familiar and the most convenient model. They are working with a subject they know better than any other and are freer to express their feelings and to experiment with new techniques. Artists who examine their emotions in their work often use common themes that express the joys and sorrows of people from different cultures around the world.

Albrecht Dürer portrayed himself as a thoughtful young scholar to show his future in-laws that he was the ideal husband for their beloved daughter. Rembrandt Harmenz van Rijn displayed his genius for transforming paint into life in a youthful self-portrait, one of the first in a series Rembrandt painted throughout his career. Too poor to pay a model, Vincent van Gogh used himself in a series of portraits. He developed new ways of depicting the changing effects of sunlight with brilliant color and expressive brush marks as unique as his fingerprints.

Arshile Gorky's haunting self-portrait expresses his love for his mother, who died when he was a teenager. Through the ghostly colors and churchlike setting, he evokes his family's ancient religious heritage. Using primary colors, Jacob Lawrence created structural forms to symbolize himself as a builder of paintings. Audrey Flack anticipated today's sophisticated computer images, which are brighter and sharper than reality, in a 1981 self-portrait that tricks the viewer into thinking that the painting is a photograph.

Great artists' self-portraits reveal their character, their spirituality, and their feelings. When you look into a mirror with the eyes of a painter, you begin to see the person behind the image.

PORTRAIT OF THE ARTIST HOLDING A THISTLE, 1493
Albrecht Dürer, German (1471–1528), parchment mounted on canvas
22 ½" x 17 ½"

*A*fter completing his apprenticeship as a painter in his hometown of Nuremberg, Germany, Albrecht Dürer continued his studies during a four-year journey through Germany and Switzerland. While he was away from home, Dürer created this self-portrait to show his future parents-in-law that he was an ideal husband for their beloved daughter.

By clothing himself in the robes of a scholar, Dürer reveals his belief that painters are learned men with a mission to educate. The eyes suggest that nothing escapes Dürer in his search for artistic perfection. He holds a thistle, the traditional symbol of fidelity, to express devotion to both his art and his future wife.

In this portrait, Dürer used *lines* to shape the figure and to create a lively feeling of movement. Red bands outline the *contours* of his black silk robe and emphasize the mass of his shoulders and arms. Lines, softened by *shading* to suggest fine linen, shape the pleats of his tunic. An undulating line that begins in the tasseled cap continues along the wavy hair and down the edge of Dürer's robe, drawing the viewer's eye from the artist's face to his hands.

Through his masterly technique Dürer created luminous colors that remain as clear today as they were five hundred years ago. Instead of canvas, he used an animal skin, called parchment, especially prepared for painting. Dürer gradually built up colors in thin layers called glazes. The *transparent* glazes allow the pale parchment to reflect light through the *highlights* that model his features and shape the folds of his cloak.

From youth to maturity, Dürer studied his inner being through self-portraits. These paintings, character studies of a brilliant and complex artist, are believed to be the first self-portraits in the history of German art.

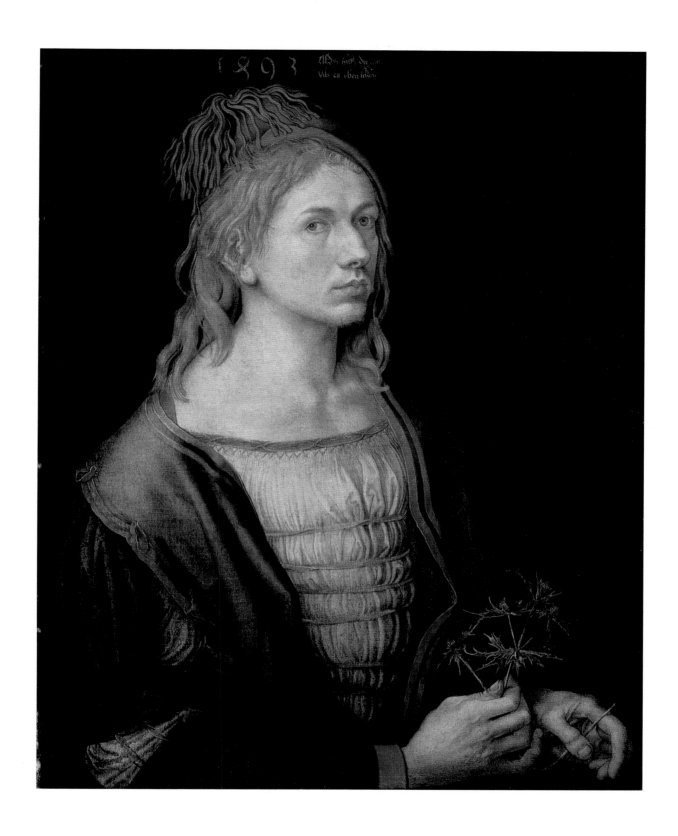

SELF-PORTRAIT, about 1514
Leonardo da Vinci, Italian (1452–1519), red chalk on paper, 13⅛" x 8⅜"

Leonardo da Vinci, the Renaissance master who painted the *Mona Lisa* and the *Last Supper,* was viewed by his contemporaries as a genius. Leonardo was not only a great painter and city planner, but also a scientist and an inventor. Among the more than five thousand pages of *drawings* that he made are designs for sophisticated military fortifications and firearms, methods of draining swamps, and a flying machine whose design anticipated the helicopter.

This drawing, the only known self-portrait of the artist, was made during Leonardo's sixty-second year. It depicts a wise, stoical man whose eyes express the painful loneliness of a visionary who sees things that others can neither see nor understand.

Leonardo made this drawing using finely sharpened red chalk called sanguine. Through variations in *line* thickness, he created a three-dimensional effect that conveys the massive size of his head. Leonardo shaped the nose with a single line that alternates from a thick stroke at the furrowed bridge to a whisper-thin line that conveys the fleshy bump in the middle. For *shading* Leonardo drew a shower of parallel diagonal strokes called hatching. Because he was left-handed,

Leonardo's hatched lines slant from the upper left to the lower right. The soft *shadow* over the eyes suggests a veil that separated Leonardo's vision from that of ordinary mortals.

Because Leonardo shifted quickly from one idea to another, he was unable to spare the time to organize his drawings, which cover an encyclopedic range of subjects. Although many of these pages have been preserved in libraries and museums, many more were scattered and lost when Napoleon Bonaparte invaded Italy in 1796.

Filippino Lippi created the soft smoky shadows defining his features by applying light transparent colors, called glazes, over a painting made with darker tones.

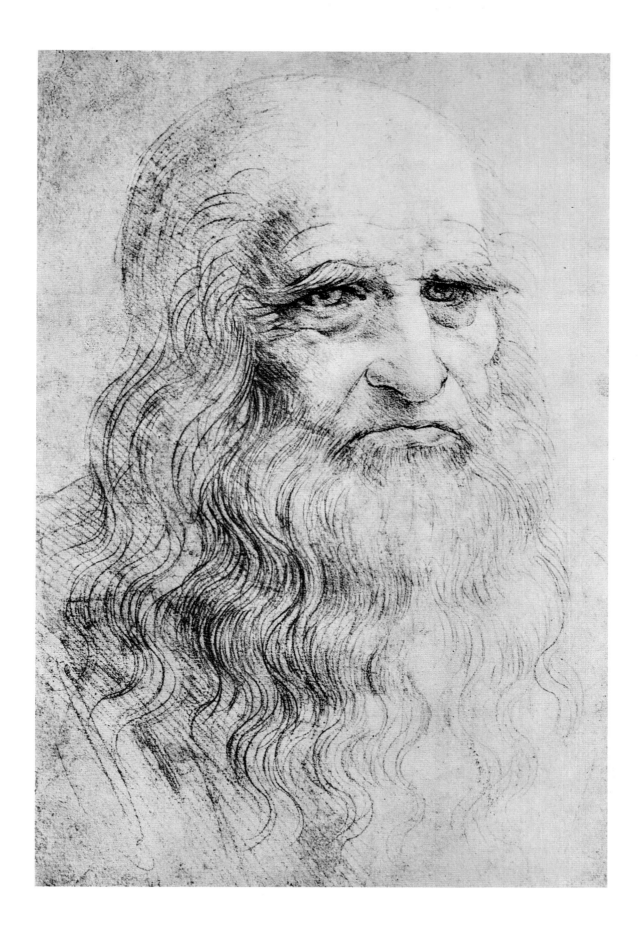

11

PORTRAIT OF A YOUNG MAN, undated
Agnolo Bronzino, born Agnolo di Cosimo, Italian (1503–72), oil on wood,
37 ⅝" x 29 ½"

*B*ronzino completed his artistic training in Florence, Italy, at a time when ideas about beauty in art were changing. The *classical* values of the Renaissance—ideal beauty, balance, and harmony—were rejected in favor of a more emotional way of depicting people. In this painting, believed to be a self-portrait, Bronzino deliberately elongated the figure and created a confusing space to evoke feelings of unrest.

Bronzino displays the artistic gifts that would soon gain the attention of his greatest *patron*, Cosimo de' Medici, the Grand Duke of Tuscany. Bronzino created an imposing presence through his casually disdainful pose. The line formed by his shoulders and arms creates a triangle that fills the space between the table and chair. The distorted *perspective* of the *background* forces the viewer to look at the handsome youth; although the precisely drawn angles and corners suggest spatial order and depth, the background is so purposefully off balance that our eyes automatically return to the figure. The wedge-shaped forms of the table and chair as well as the exaggerated pose of the hands emphasize the angular geometry of the picture.

Bronzino's innovative *composition* is matched by his sophisticated use of color. With cold shades of green and red, he created icy flesh tones softened only by the warm red in the lips. Bronzino added green to the black tunic and the white collar, giving the painting a cool feeling, which is emphasized by the magenta of the table.

Although Bronzino created important *murals* for the Medici palace, it is his portraits of the people whose companionship he most enjoyed—the great poets, philosophers, and artists of his generation—that best demonstrate his greatness.

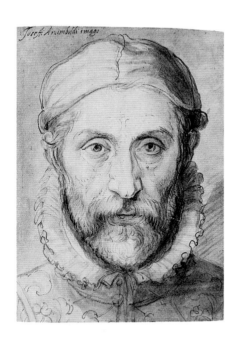

Giuseppe Arcimboldo, who usually formed people in masses of delicate flowers, combined blue pencil and ink in this realistic self-portrait he drew in 1575.

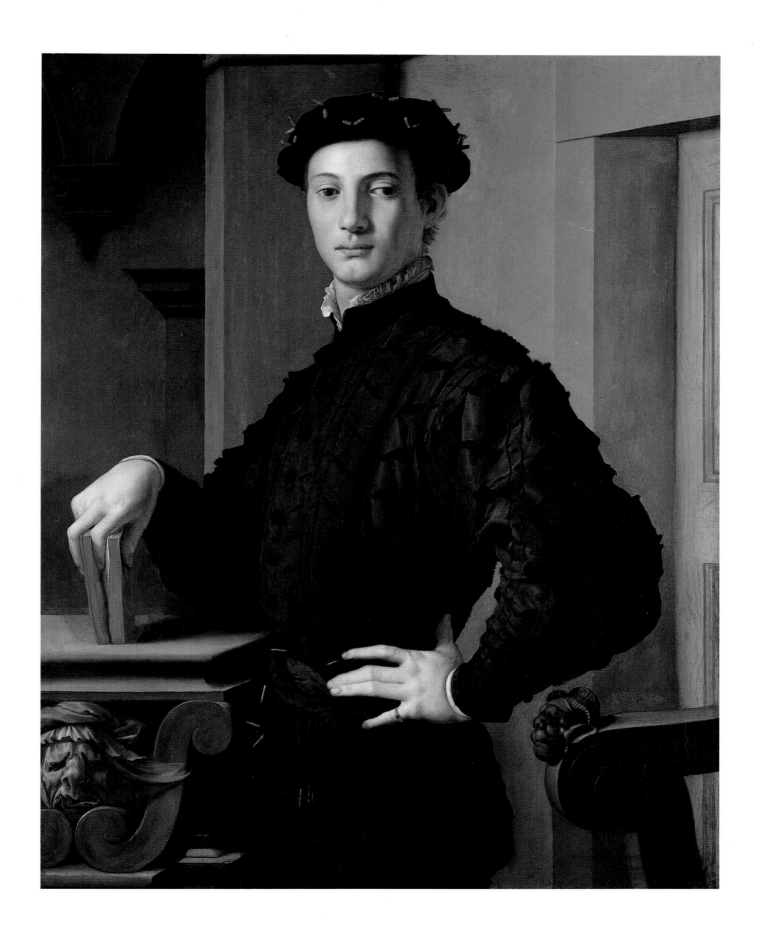

SELF-PORTRAIT, about 1629
Rembrandt Harmenz van Rijn, Dutch (1606–69), oil on panel, 14⅞" x 11⅜"

Rembrandt Harmenz van Rijn created more than eighty paintings of himself over a period of forty years. From the confident young man of twenty-three (opposite) to the older man in the *drawing* below, his self-portraits comprise a revealing autobiography of an artist who searched for the truth in life through the perfection of his work. Rembrandt's visual self-discovery was unusual, for in the seventeenth century, artists' self-portraits were considered a vain and foolish subject compared to pictures of biblical and historical events.

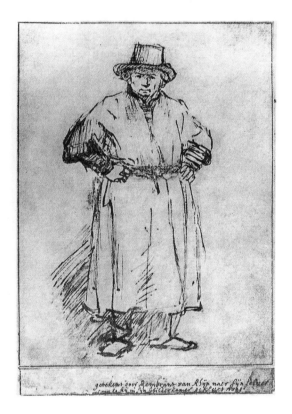

In a pen-and-ink drawing made in the 1650s, Rembrandt portrayed himself dressed for work. His stern expression suggests that he is examining a work in progress.

Rembrandt projects an aura of power by wearing the armored neck plate of a militia-man. Through the balance of light and dark areas, a technique called chiaroscuro, he focuses attention on his critical eyes. Rembrandt nearly masks one side of his face in mysterious reddish brown *shadows*, forming a strong *contrast* with the lighted areas on the left side of the painting.

Rembrandt rejected conventional methods of building up colors in thin layers that would give almost predictable results. Instead, he blended colors on the panel, creating expressive variations in *tone* and *texture* that make each brushstroke come to life. In this picture, Rembrandt added a golden hue to the skin color, hair, and bronze collar, suffusing the portrait with warm light. With a single stroke of brilliant white paint he gave the lace collar a magical quality that makes the deep shadows seem even darker.

This self-portrait was created in the same year that the young artist captured the attention of his first important *patron*, Christian Huygens. He recognized Rembrandt's unusual gift, which goes beyond a masterful technique, for expressing more than the mood and appearance of his subjects.

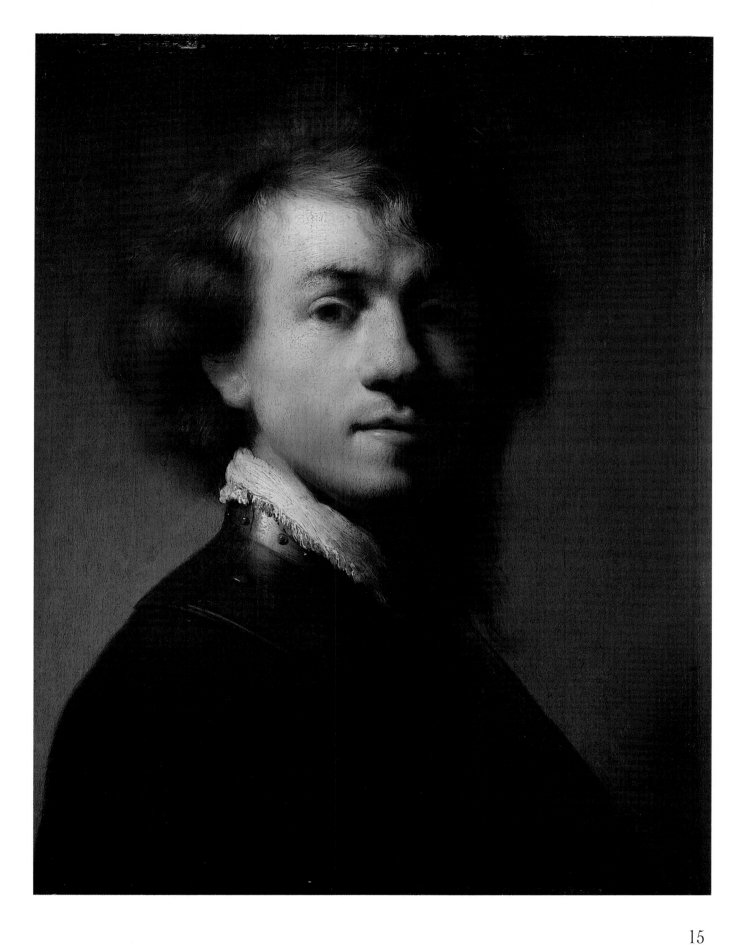

THE ART OF PAINTING, about 1665
Jan Vermeer, Dutch (1632–75), oil on canvas, 47¼" x 39⅜"

Jan Vermeer, who lived in the Netherlands during the seventeenth century, was better known in his lifetime as an art expert than as a painter. Today, the fewer than forty paintings created by the Master of Delft are priceless.

Vermeer invites us into his studio to observe a work in progress—a painting of Clio, the ancient Greek muse of history. Vermeer gave this scene a feeling of energy through his knowledgeable use of *perspective* and the ways in which he deliberately broke the rules. He conveys a sense of depth through the curtain framing the scene and the diagonal floor tiles that gradually become smaller toward the *background*. The model portraying Clio is in proportion to the furniture and room. However, the painter and the model are not in proportion to each other. If Vermeer had followed the rules of perspective exactly, the model would be too large for the room. Vermeer focuses attention on the rapt concentration of the artist at work through his exaggerated size and dynamic pose.

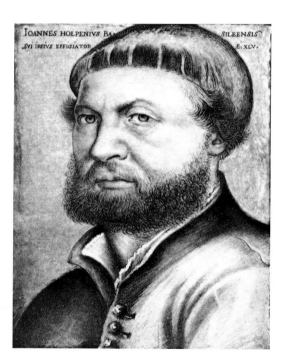

Hans Holbein the Younger created shadows with delicate parallel lines, called hatching, using chalk sharpened to a fine point.

Vermeer achieved the luminous *tone* of this painting by restricting his *palette* to a few dominant colors: ultramarine, vermilion, and yellow. He fashioned Clio's sumptuous robe in ultramarine, which he also used in the map, the fabric on the table, and the tapestry. The vermilion in the painter's stockings is deepened with brown to make the russet color in the curtain and map. Vermeer saturated the white wall and the artist's black jacket in the pale yellow of soft daylight, creating a feeling of warmth.

This self-portrait, said to be an allegorical painting that proclaims the importance of painters in the history of culture, shows Vermeer at the height of his artistic power.

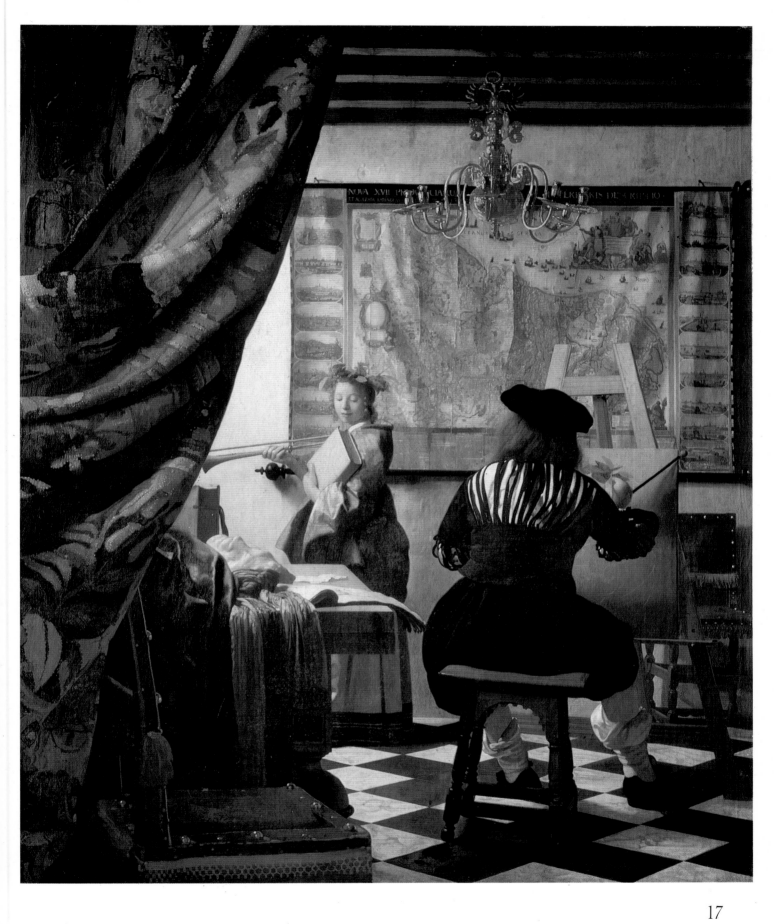

SELF-PORTRAIT WITH TWO PUPILS, 1785
Adélaïde Labille-Guiard, French (1749–1803), oil on canvas, 83" x 59 ½"

*A*délaïde Labille-Guiard became a painter in France at a time when women were excluded as students and as teachers from state-operated art schools. Labille-Guiard took private lessons and specialized in portraiture. In 1782 she was nearing her goal of acceptance by the influential French Academy. However, it was falsely rumored that her teacher, François André Vincent, finished her paintings. To disprove these claims, Labille-Guiard invited several prominent Academicians to sit for portraits. Impressed by her talent, they campaigned for her acceptance by the Academy, to which she was elected in 1783. It is believed that Labille-Guiard created this 1785 self-portrait to promote her efforts to broaden opportunities for women artists.

In this detail we can see that Adélaïde Labille-Guiard, using fine brushstrokes, paid meticulous attention to every feather in her hat.

Labille-Guiard spotlights her commanding presence through dramatic *contrasts* between light and dark areas. Daylight pours in from the right to illuminate the artist, setting off her luxurious silken gown. She infused her hair, her skin, and the *shading* in her dress with warm umber *tones* that, by *contrast*, emphasize the cool brilliant hues in the fabric.

Labille-Guiard gave this quiet scene a feeling of energy through the sweeping folds of her stylish gown, which she fashioned using a painting technique called fat over lean. Labille-Guiard first created the shaded areas with dark colors thinned with *turpentine*. After the thin, or lean, layer had dried, she applied gleaming *highlights* with paint thickened, or fattened, with oil. Through this technique, Labille-Guiard ensured that the thick highlights would not crack as the paint dried.

Labille-Guiard's self-promotion was a success, for in 1790 she convinced the French Academy to hire women as teachers.

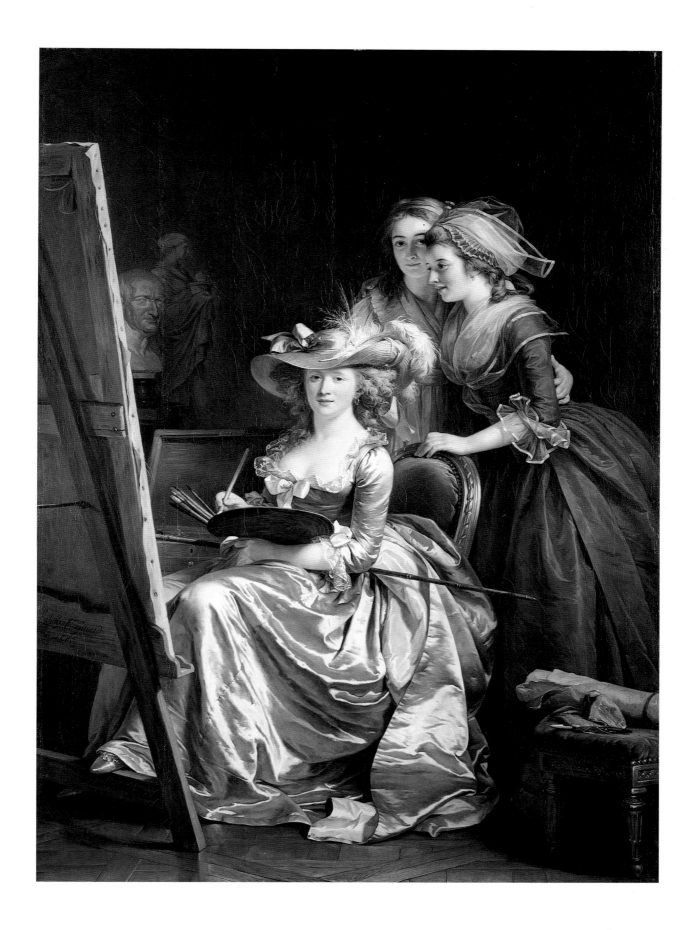

MOTHER ANTONY'S TAVERN, 1866
Pierre-Auguste Renoir, French (1841–1919), oil on canvas, 76½" x 51"

In the spring of 1866, Pierre-Auguste Renoir went to the countryside with his former classmate Jules Le Coeur and another artist named Alfred Sisley. At night they often went to Mother Antony's, an inn frequented by artists who came to paint in the nearby forest of Fontainebleau. Renoir created this self-portrait with his artist companions, Mother Antony, and her dog, Toto, as a remembrance of the good times and the discussions about painting they enjoyed.

Renoir created a serious atmosphere through the dark colors and the rapt attention of himself, standing, and Sisley, seated, listening to Le Coeur, in the straw hat. The figures are arranged in a triangular *composition*, with Renoir's head forming the apex. The *design* is emphasized through the diagonal ceiling beam at the right. Renoir draws the group together through the white tablecloth and the apron worn by their hostess.

By staging this scene in somber black, white, and brown, Renoir focuses attention on the portraits. He created lifelike flesh tones in the faces and hands by building up paint in transparent layers called glazes. Renoir learned this method, perfected by master artists of the seventeenth century, by studying their work in the Louvre museum. He formed the *shadows* defining Sisley's head with a blue-gray tone. Over this he added translucent films of ivory and pink that allow the bluish shadows to show through, creating soft, three-dimensional *contours*. He then applied white *highlights* on the forehead, nose, and chin.

In his later years, Renoir wrote in his journal that this group portrait, painted before he had become famous, was one of the paintings that he remembered with the greatest pleasure.

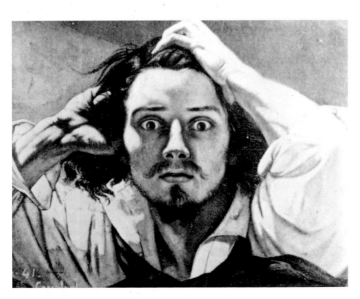

Gustave Courbet portrayed feelings of dread, fear, and desperation in this self-portrait made in the 1840s.

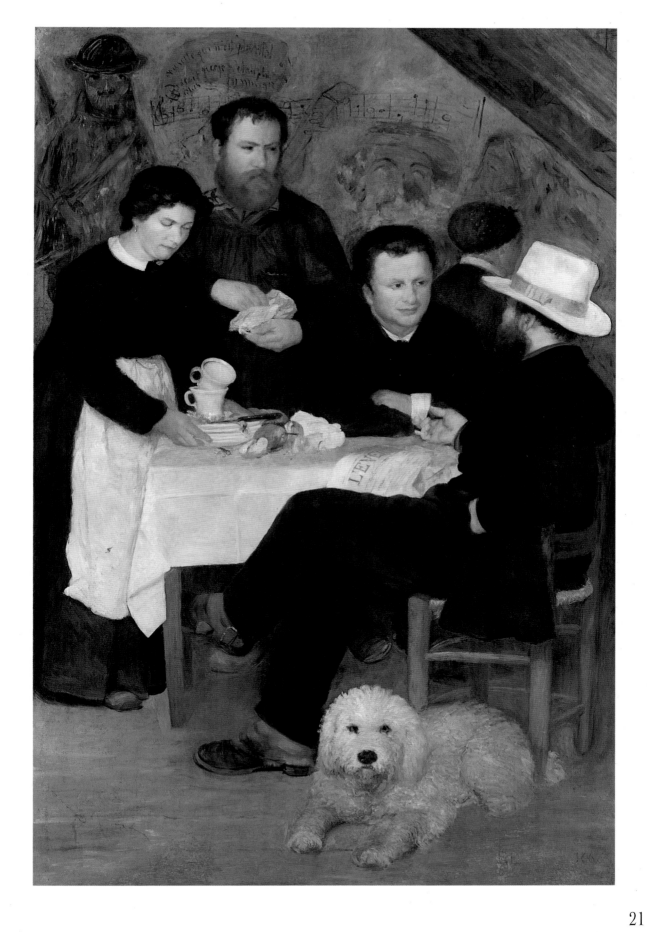

SELF-PORTRAIT IN A FLOWERED HAT, 1883

James Ensor, Belgian (1860–1949), oil on canvas, 30½" x 21¼"

James Ensor grew up in the ocean resort city of Ostend, Belgium, where his parents owned a souvenir shop. Ensor was a daydreamer who hated school. His understanding parents allowed him to leave school at age fifteen to study art in Brussels. The paintings he created—pictures of real life that were sometimes ugly—shocked and angered his teachers, who preferred beauty to realism.

Ensor often used his own image to study expressions, gestures, and emotions. He appears, thinly disguised, as a character in many of his major paintings. In this 1883 self-portrait, Ensor expressed his feeling that life is a series of tragic circumstances that are often disguised as comic events. Beneath a whimsical straw hat decorated with flowers and feathers, Ensor's face reveals his deep sadness.

Ensor creates a disquieting mood through the dark colors and the indistinct *background*. The rounded frame suggests the entrance to a strange and mystical place. As a tribute to the great Flemish painter Peter Paul Rubens, Ensor adopted the old master's style for his hair, beard, and clothes. But he used a modern painting technique, applying bold thick strokes of paint to convey the play of light on his sharp features. Ensor molded the shape of his nose with a red *shadow* that suggests light reflected from the reddish background. In *contrast* to the expressive details that form the face and hat, the jacket is a simple triangle of black. A slashing stroke of gray forms a scythe, a traditional symbol of death.

James Ensor soon became the most internationally famous Belgian painter since the seventeenth century. Although he painted until his death at age eighty-nine, Ensor was unable to sustain the passion that inspired his youthful work.

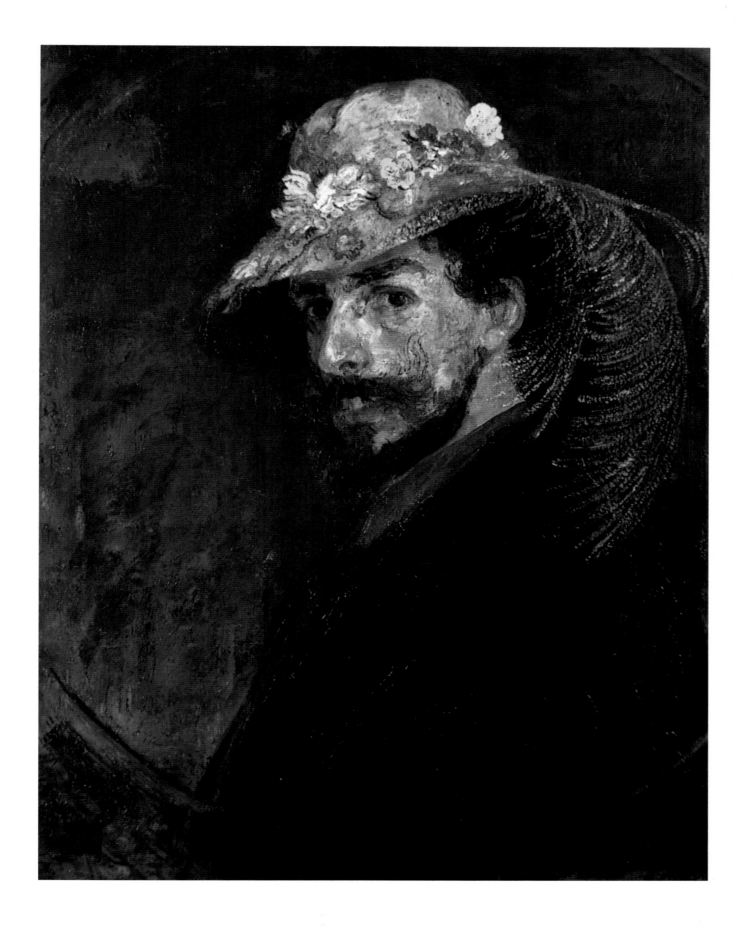

SELF-PORTRAIT WITH STRAW HAT, about 1888
Vincent van Gogh, Dutch (1853–90), oil on canvas, 16" x 12 ½"

In 1886, Vincent van Gogh moved to Paris, France, to live with his brother Theo. Because he was too poor to hire models, van Gogh painted self-portraits in which he experimented with new ideas about painting. In this portrait, van Gogh's signature style emerged in an explosion of rhythmical brushstrokes.

Van Gogh shaped his straw hat, face, and jacket with directional strokes of paint. He formed the hat with curved parallel *lines* of yellow, tan, and green that define its *contours* and *texture*. Diagonal marks define the sharp planes of his cheeks and forehead; blue and green comma-shaped marks denote the rumpled jacket. Van Gogh's intense expression combined with the vigorous dashes of thick paint create a feeling of restless energy.

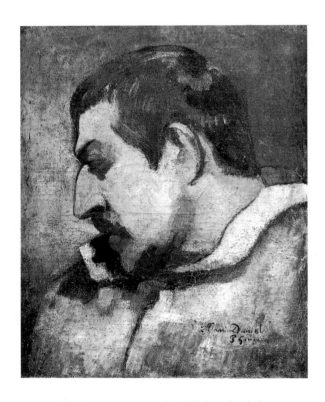

In this 1896 painting made in Tahiti, Paul Gauguin expressed the despair he felt when poor health and poverty prevented him from returning to Europe to visit his friends.

The wonder of this painting is the way in which van Gogh created the effect of *transparent shadows* through the use of brilliant rather than dark colors. Van Gogh applied bright colors side by side over a tan *background*, which he left partially uncovered between brushstrokes. Instead of mixing hues on a *palette*, van Gogh applied strokes of red and green that fuse in the viewer's eyes with the muted tan color to create a transparent shadow on the forehead. Dashes of chrome yellow on the face, neck, and jacket become sunlit reflections of the yellow hat. The triangle of white forming his shirt emphasizes the clear, bright *tone* of the portrait.

Over a period of two years, van Gogh created twenty-two self-portraits that chronicle the artist's turbulent emotions as he wrestled with new ways to express how light gives form to objects.

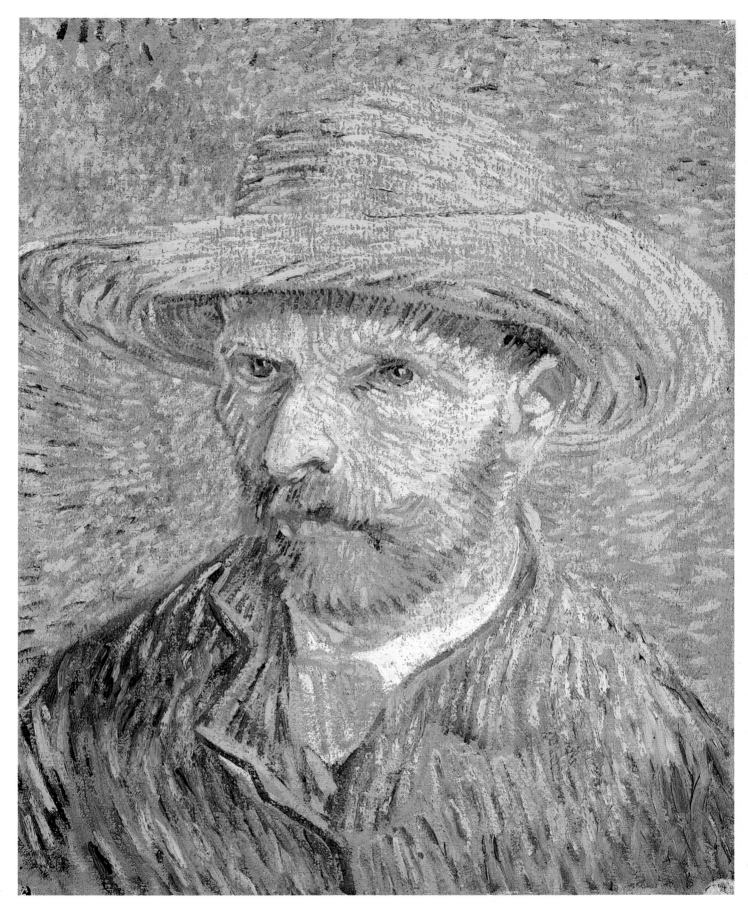

SELF-PORTRAIT WITH A PALETTE, 1906
Pablo Picasso, Spanish (1881–1973), oil on canvas, 36 ¼" x 28 ¾"

In the spring of 1906, Pablo Picasso visited the remote mountain village of Gósol, Spain. Fascinated by a simply carved wooden sculpture dating from the twelfth century, Picasso whittled a small statue from a gnarled stick, retaining the natural curves of the wood to shape the figure.

The process of carving inspired Picasso to reinvent the way he depicted people in his paintings. In this masklike self-portrait, Picasso stripped away distracting details in the same way he had removed unnecessary wood to sculpt the little statue. He painted only the *lines* and shapes that clearly conveyed the *forms* of his head and body. Picasso portrays himself as a self-absorbed, almost aggressive young man through the fixed expression and clenched fist.

Picasso used his brush like a chisel, painting with a range of colors that characterizes Gósol's rocky terrain: umber, sienna, gray, and white. He defined the features with oval shapes for the eyes, jaw, and hairline and a triangle for the nose. Patches of white emphasize the sharp planes of the face. He painted the figure with blocks of color, using umber lines that vary in thickness to convey the solid, three-dimensional form. The torso is a flatly painted square of white broken by gray brush marks that create a sense of bulk. With bold rounded lines, he emphasized the broad chest and powerful right arm. Picasso scrubbed a thin layer of white paint over umber for the background, enveloping the figure in a misty *tone* that suggests the self-contained world of his studio.

In this portrait, Picasso combined his love of primitive art with his constant search for innovative ways to express his artistic vision. The next year he created what has been called the first modern painting of the twentieth century, *Les Demoiselles d'Avignon.*

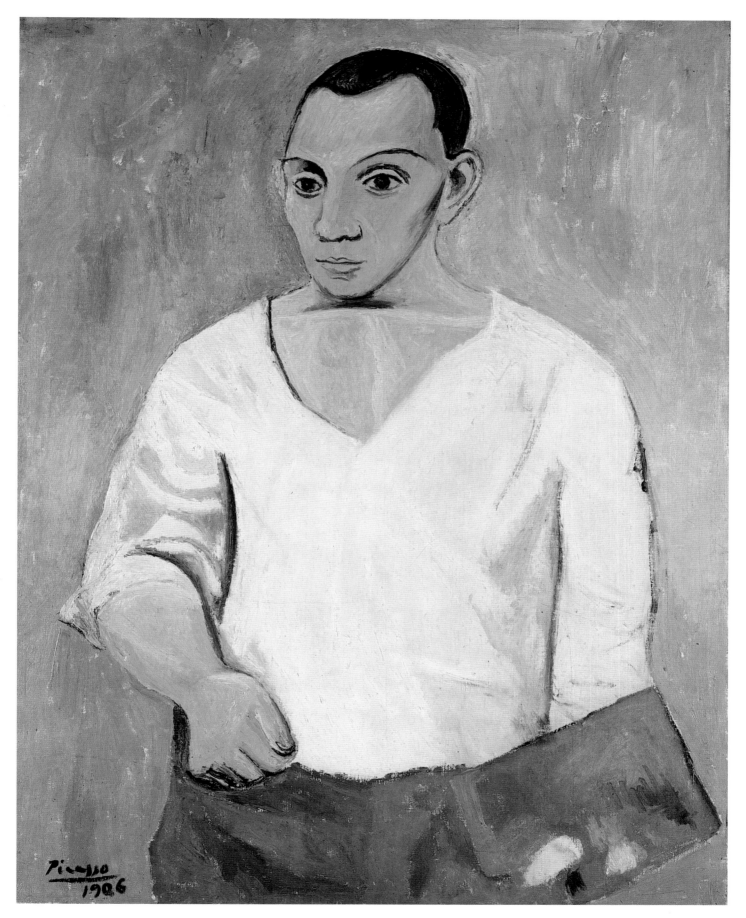

SELF-PORTRAIT, 1912
Otto Dix, German (1891–1968), oil and tempera on panel, 29" x 19½"

Otto Dix grew up in the working-class town of Unternhaus, Germany. Encouraged by a teacher who recognized Dix's unusual gift for drawing, he left school to study art at the age of fourteen. Dix first worked for a decorative artist to learn the techniques of painting, then enrolled in the Dresden School of Arts and Crafts. In the Dresden museums, he studied the work of Albrecht Dürer, who is regarded as a hero in Germany, both by artists and by ordinary people. Dix created this self-portrait in order to study painting techniques perfected four hundred years earlier by Renaissance artists.

Dix modeled this painting on Dürer's youthful self-portrait (page 9). The pose is nearly identical, down to the flower held between his thumb and forefinger. But Dix, who was moved by Vincent van Gogh's emotional self-portraits, created an uneasy feeling through the scowling expression and the harsh lighting.

Like sixteenth-century German artists, Dix used a wooden panel, which is more resistant to the damages of time than *canvas*. He first prepared the panel with a satin-smooth white prime coat called a ground. Dix created lustrous skin tones and the velvety texture of corduroy through the application of thin layers of oil paint called glazes. Drawing with fine brushes and dark brown paint, he created contrasting tones in the jacket and hair. Because the glazes are *transparent*, the white ground underneath acts as a reflector. Light bounces off the surface of the painting, creating a lustrous effect that is impossible to achieve using *opaque* colors.

As a student, Dix mastered a nearly lost painting technique. The craft of painting was important to Dix, who wanted his work to last for hundreds of years.

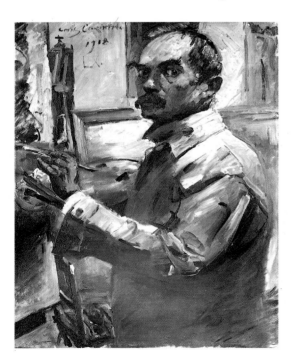

Oscar Kokoshka, a comtemporary of Otto Dix, applied paint with thick, expressive brushstrokes called impasto in this picture of himself at the easel.

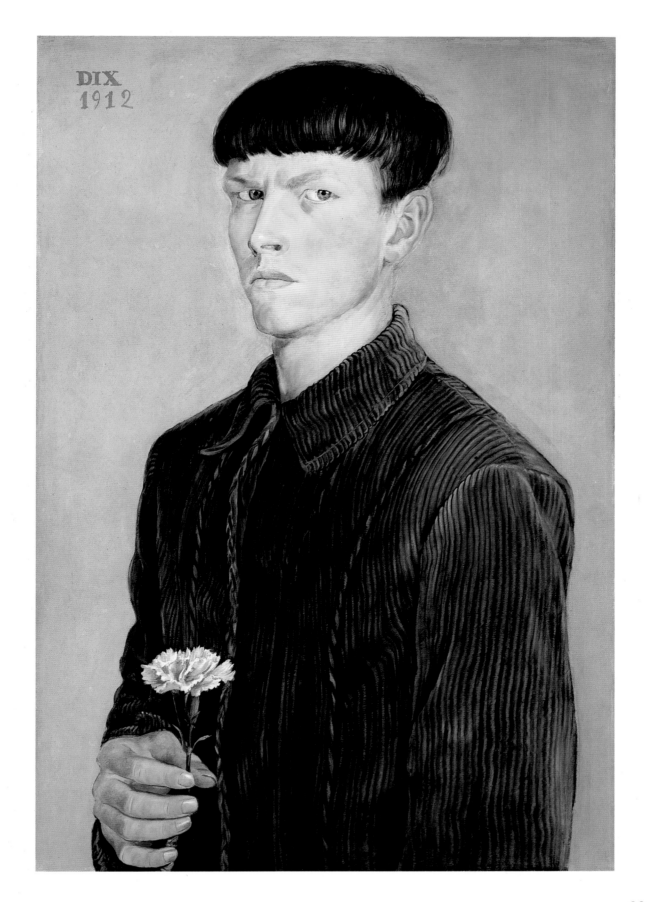

DOUBLE PORTRAIT WITH WINE GLASS, 1917
Marc Chagall, Russian (1887–1985), oil on canvas, 91¾" x 53½"

When he was a student in Russia, Marc Chagall's teachers ridiculed his imaginative way of painting. They thought he lacked the skill to picture the world the way it appeared to them. In 1910, Chagall moved to Paris, France, where he was free to express his personal vision. His paintings of a fantasy world in which people, animals, and objects drifted through dreamlike landscapes captivated those who saw his first one-person exhibition in 1914. Chagall joyously returned to Russia. There, however, he was still unknown. Chagall painted this lyrical wedding portrait of himself and his wife, Bella, who supported him with love and companionship while he struggled once again to establish his reputation.

Chagall stylized the figures, following their natural forms but elongating and simplifying them. The figures divide the *canvas* into two zones of contrast-

ing colors: a cool misty white on the left and a fiery golden blaze on the right. Using a narrow range of bright complementary colors—red and green, purple and yellow—he cast the figures in sharp relief against the cool brown hues in the distant city.

Chagall's lustrous colors and delirious smile make us feel the happiness he and his wife, Bella, felt when the Russian art world finally recognized his talent.

Chagall created a variety of *textures* that make this painting gleam like a stained glass window. He painted the faces smoothly in ivory and brown, modeling the features with soft shading and *highlights*. Chagall shaped his jacket as a flat red *silhouette*. He formed the mottled *background* on the right by applying yellow and orange over a greenish background that shows through to shape the cloud-like texture.

In 1917, Chagall was appointed director of a new art school in his native city, Vitebsk. After struggling in poverty for more than ten years, Chagall was finally recognized in his own country.

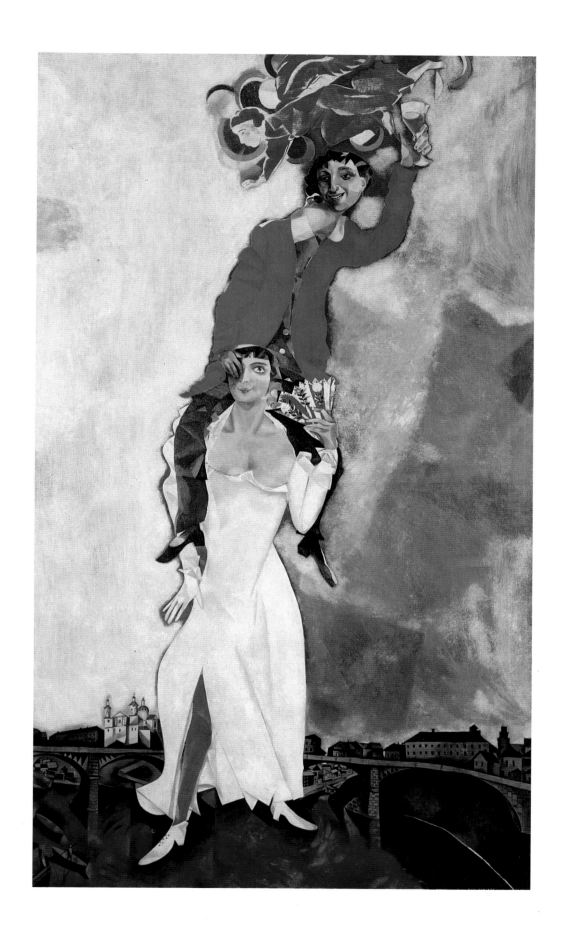

WHERE FRIENDS MEET, 1922
Max Ernst, German (1891–1976), oil on canvas, 51⅛" x 76¾"

Max Ernst was horrified by the destructiveness of World War I, the first war waged using airplanes. He joined a group of young European artists who formed a radical approach to painting, sculpture, poetry, and the theater called surrealism. They rejected rational thinking in favor of the world of dreams, which they believed was the only true reality.

Ernst painted this imaginary group portrait of the leading surrealists and their heroes, including Sigmund Freud, the first psychiatrist to interpret dreams. Ernst portrayed himself as the seated man wearing a green suit (4). He created the intense, but irrational, reality of a dream through the combination of realistic and unbelievable elements. The faces are as lifelike as photographs, but some are black and white, like the snapshots of the time, and some are depicted in color. The seated figures occupy space instead of chairs. Ernst staged the gathering on an alpine glacier rather than in a living room.

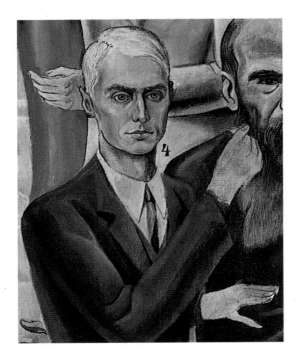

This detail shows that Max Ernst has his eyes on the future as he makes a toast to his fellow artists and heroes.

Ernst took a bird's eye view of the group and created a disquieting atmosphere through distorted *perspective*. The large figures of poets Paul Eluard (9) and André Breton (13) loom over the people sitting in the foreground. The Russian author Fyodor Dostoyevski (6) is disproportionately large compared to the others in the front row. The apple held by sculptor Jean Arp (3) is bigger than the mechanically dissected fruit in the *foreground*.

In this group portrait, Ernst anticipated André Breton's 1924 Surrealist Manifesto, or statement, which said that art based on artists' dreams was the only valid form of self-discovery and social protest.

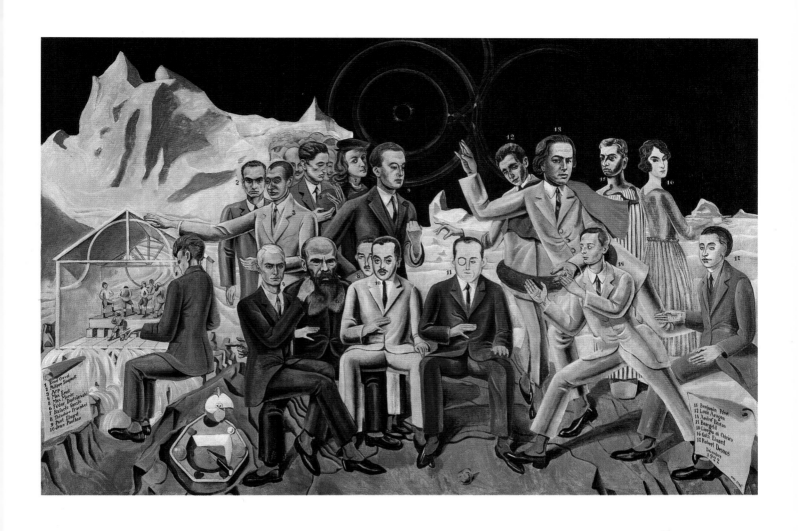

SELF-PORTRAIT IN TUXEDO, 1927
Max Beckmann, German (1884–1950), oil on canvas, 55 ½" x 37 ¾"

When World War I broke out in 1914, Max Beckmann said to his wife, Minna, "I will not shoot at the French. I've learned too much from them." As an army ambulance driver, however, Beckmann witnessed death and destruction at the front lines. The experience was so disturbing that he suffered a nervous breakdown in 1915. After recovering, Beckmann returned to a Germany devastated by foreign occupation, economic depression, and hunger. Lost in this broken world, he searched for his identity as a man and an artist in a series of powerful self-portraits.

By 1927, when he painted this regal image, Beckmann had achieved public acclaim. Wearing elegant evening attire, he strikes an aristocratic pose that projects a sense of power and pride.

Beckmann also created an unsettling mood through the harsh lighting scheme and almost monochromatic mixtures of black, white, and brown. He divided the figure down the middle, casting the left side in deep *shadow* and illuminating the right side with glaring light. He defined the strong features on the right with brilliant, posterlike *highlights* that create a bold, three-dimensional effect in *contrast* to the flatly painted figure. Beckmann made the black suit seem even blacker with a blaze of white that forms the shirt. The ghostly *background*, painted in broad patches of silver gray, emphasizes the dynamic outline of the figure. The eyes express conflicting feelings of confidence and doubt.

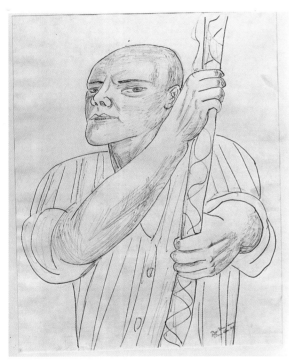

During a visit to the Rocky Mountains in 1949, Max Beckmann portrayed himself as a fisherman. Sharp rounded lines and expressive shading emphasize his powerful hands grasping a fishing rod.

More than any other artist since Rembrandt, Beckmann studied his face to examine and understand his emotions. This is one of more than eighty self-portraits that he created over a period of fifty-one years.

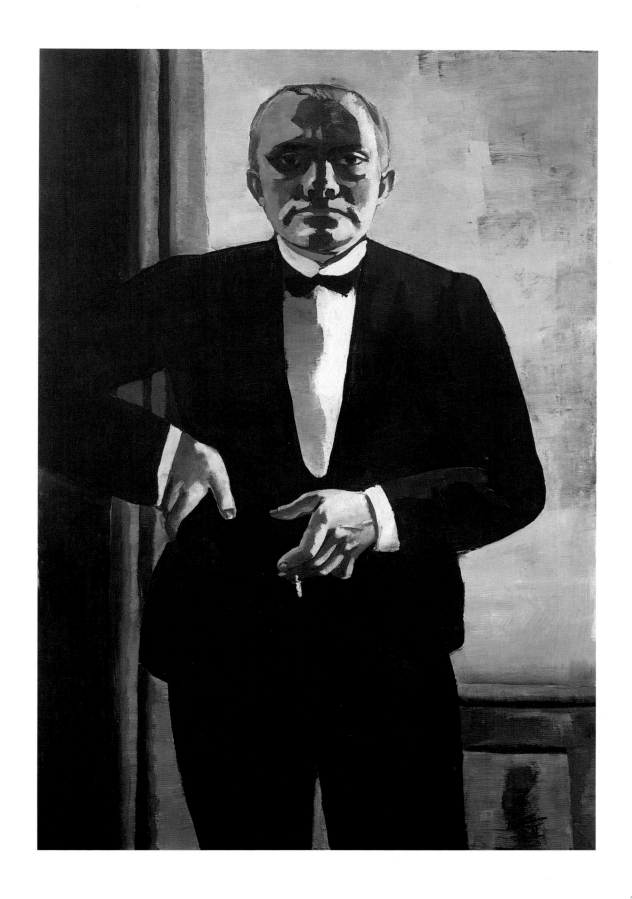

THE ARTIST AND HIS MOTHER, about 1926–34
Arshile Gorky, American, born in Armenia (1905–48), oil on canvas, 60" x 50"

Arshile Gorky was born in Armenia with the surname Adoian. His happy childhood ended abruptly in 1915, when Turkish forces invaded Armenia and seized the Adoian's farm. His family fled to a remote mountain village to escape persecution, but four years later Gorky's mother died of starvation. At the age of fifteen, Gorky departed alone for the United States to rejoin two sisters who left Armenia in 1918.

Gorky developed an appreciation of icons—paintings used in religious ceremonies—from his mother, who was descended from generations of Eastern Orthodox priests. In this self-portrait, Gorky depicts himself as a child offering flowers to his beloved mother, posed to resemble an icon of the Virgin Mary.

Gorky makes us feel that we are in an earlier time through the *abstract*, almost churchlike setting, the figures that seem to float in space, and the ghostly colors. He simplified the figures with flatly painted areas of white, muted yellow, and gray, and created a sense of mass through the swelling curves of the *silhouetted* forms. The expressive brush marks on the clothes, in *contrast* to the crisp outlines, give a feeling of movement to this otherwise still scene.

Gorky made the faces appear three-dimensional with distinctive shapes and *shadows*. He conveyed the roundness of his head through the arcs forming the hairline. Gorky painted his mother's face as an oval, which he rounded through the simple shading that defines her features and the shadow cast by her veil. The cool blue that Gorky used for the eyes intensifies the feelings of loss and loneliness.

In this symbolic portrait, Gorky created a modern icon to remember his mother and to express his deep pride in their religious heritage.

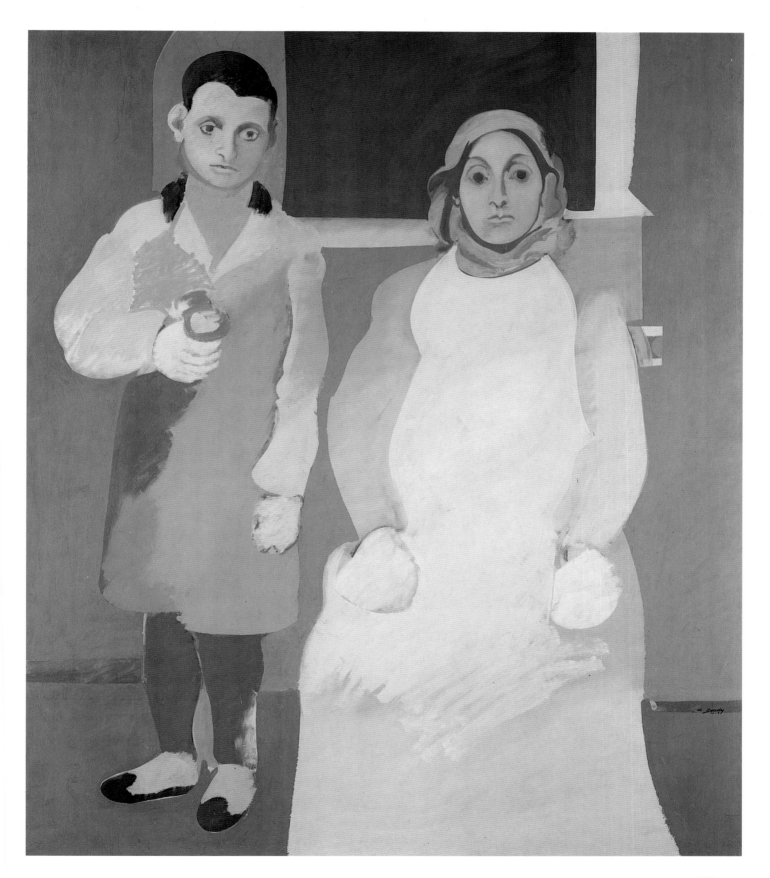

SELF-PORTRAIT WITH A BEER STEIN, about 1935
Philip Evergood, American (1901–73), mixed media on gesso panel, 16" x 12"

Philip Evergood was a rebel. His wealthy family sent him to Cambridge University in England to study law, but he left to study painting and sculpture. When he returned to New York City, Evergood took a job as a handyman and continued to paint during his time off. He depicted the misery caused by the Great Depression of the 1930s in paintings that showed the terrible problems of the poor and unemployed. Evergood also believed in the power of art to create happiness. He once said, "My first objective is to enjoy myself like a kid playing with mud pies. In enjoying myself I hope to entertain other people."

In this self-portrait, Evergood invites us to leave our troubles behind and join a festive party. He creates a feeling of fun through vividly contrasting colors and painting styles.

Evergood shaped his portrait with bold black *lines* that define the features and hands as clearly as in a comic strip. With a palette knife, a tool used for blending paint, he applied the colors thickly and added more paint with a brush, stirring up *textures* to form the *contours* of his cheeks and jaw.

In contrast to the clear lines of the self-portrait, Evergood painted the party goers with bold expressive brushwork and primary colors that recall young children's art. He created the shadowy effect of a dark nightclub by laying a film of *transparent* black paint over the *background* and over some of the figures. Streaks of bright yellow next to the lamps focus attention on the women's stylish dresses.

In this exuberant painting, Evergood expresses his optimism and love of life even during hard times.

Philip Evergood used a soft, sharp pencil to create velvety shading on rough textured paper, making the white areas in this drawing gleam with light.

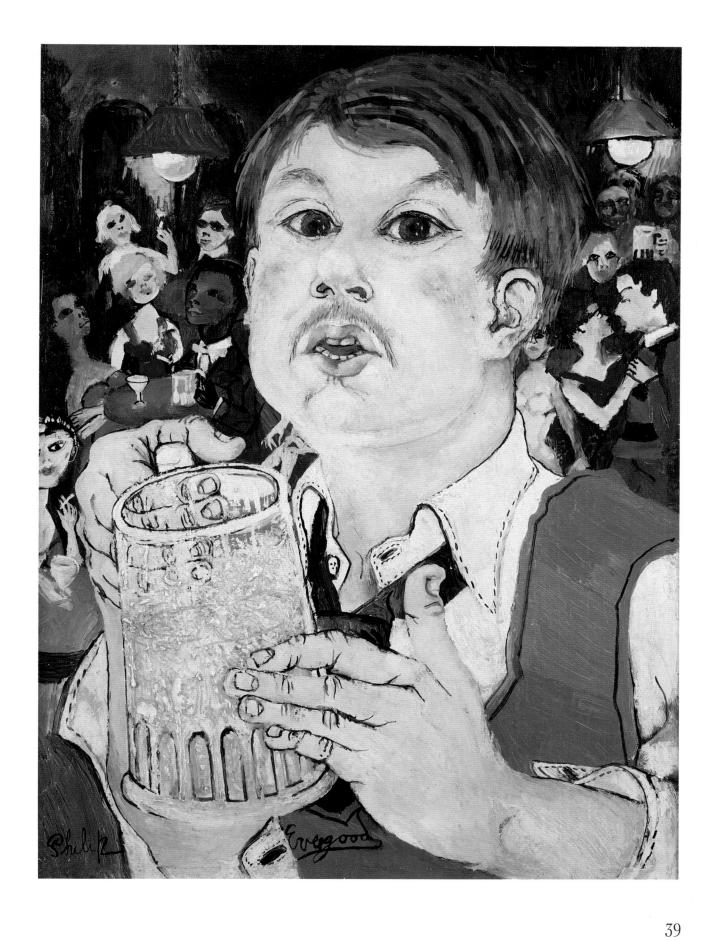

SELF-PORTRAIT WITH MONKEY, 1938
Frida Kahlo, Mexican (1907–54), oil on masonite, 16" x 12"

Frida Kahlo was among the first generation of women to be offered a free education in Mexico. Her life and art were influenced by this new freedom for Mexican women and by personal tragedy. Kahlo studied native Mexican painting and folklore, which she later incorporated into her art. When she was eighteen years old, Kahlo nearly died in a bus accident. Forced to stay in bed for two years, she began painting to escape from pain and loneliness.

In this self-portrait, which she created thirteen years later, Kahlo projects awareness of her powers as an artist and her pride as a woman. She constructs an image so sharply detailed and richly colored that it seems beyond reality. Using fine brushes, Kahlo created expressive *textures* in the prickly cactus and jagged leaves in the *background*, forming a striking contrast to her smooth skin and silky hair.

Kahlo balanced the *composition* with vertical and rounded *forms*. She emphasized her long neck through the lines of the tall cactus on the right. The roundness of her eyes and the monkey's is echoed by the pre-Columbian necklace and her rounded neckline. Kahlo creates a sense of depth through the blue area that suggests a distant sky and the cool greens that seem to recede in space. In *contrast*, her head and shoulders, painted in warm, earthy tones, seem to loom above the jungle. With a touch of humor, Kahlo mirrored her own expression in the monkey's face.

Frida Kahlo created a unique, autobiographical body of work in which she reveals the inner strength and passion with which she overcame her physical disabilities.

In the background of this 1944 self-portrait, Diego Rivera included a section of his mural depicting a flower vendor, a traditional figure in Aztec culture.

40

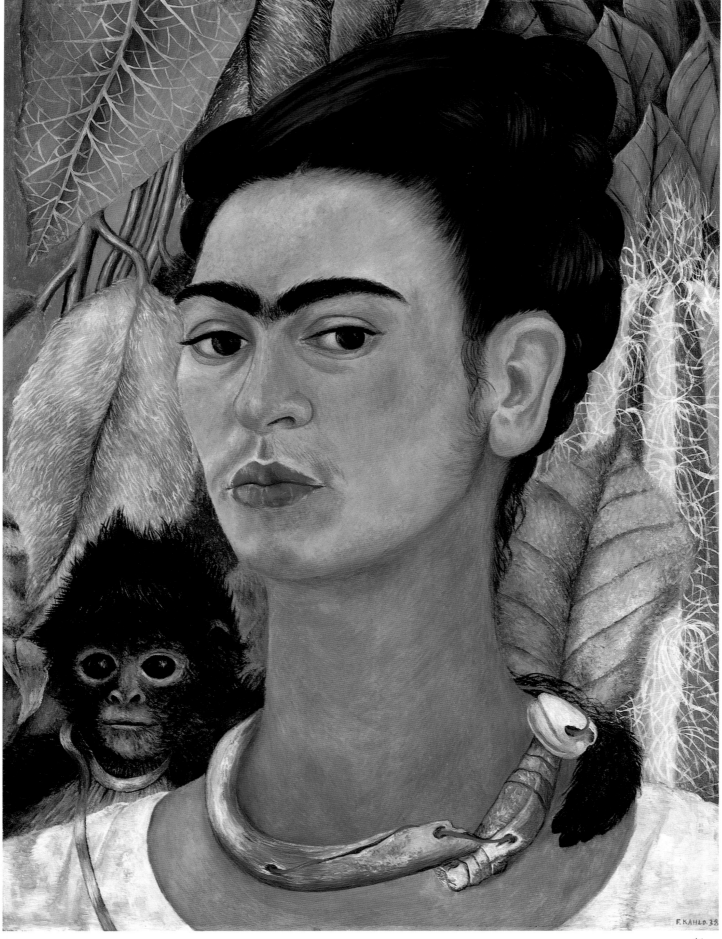

THE STUDIO, 1977

Jacob Lawrence, American (born 1917), gouache on paper, 30" x 22"

Jacob Lawrence grew up in New York City during the Harlem Renaissance of the 1930s. He was influenced by African-American poets and philosophers, such as Langston Hughes and Alain Locke, who urged young artists to discover their heritage. Lawrence created a series of paintings depicting the life of Frederick Douglass, a black American author who bought his freedom from slavery in 1847 with money he had earned through teaching. Lawrence received public acclaim at age twenty-five through the exhibition of his work at the Baltimore Museum of Art.

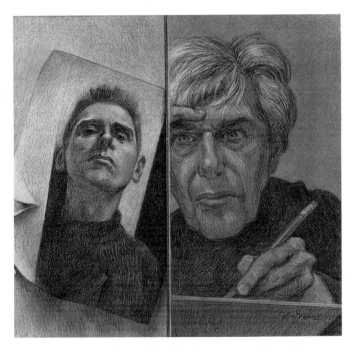

The contemporary artist Paul Cadmus remembered his youth in this dual self-portrait done with soft pencil on textured paper.

In 1977, Lawrence painted *The Studio*, a self-portrait in which the artist's working space symbolizes his character. Lawrence constructed a scene bristling with the energy of bright primary colors. A zigzag stair rail slices through the room. He chose a high point of view and tilted the floor down to invite the viewer into the busy workplace. Lawrence exaggerated the size of his hands holding the tools of his trade to represent the artist's power as an image builder.

Lawrence painted posterlike blocks of color with opaque *watercolor* called gouache. He created a feeling of depth using tonal variations of flat color rather than *shading* and *highlights*. For example, he made the bright yellow wall seem distant through the flatly painted areas of tan, which are formed by mixing yellow and brown. Lawrence painted slabs of brilliant white around the stairs to make the figure stand out from the object-filled scene.

Lawrence, who said that we can understand his work better by seeing his studio than by hearing him speak, gives us a painting that clearly proves his point.

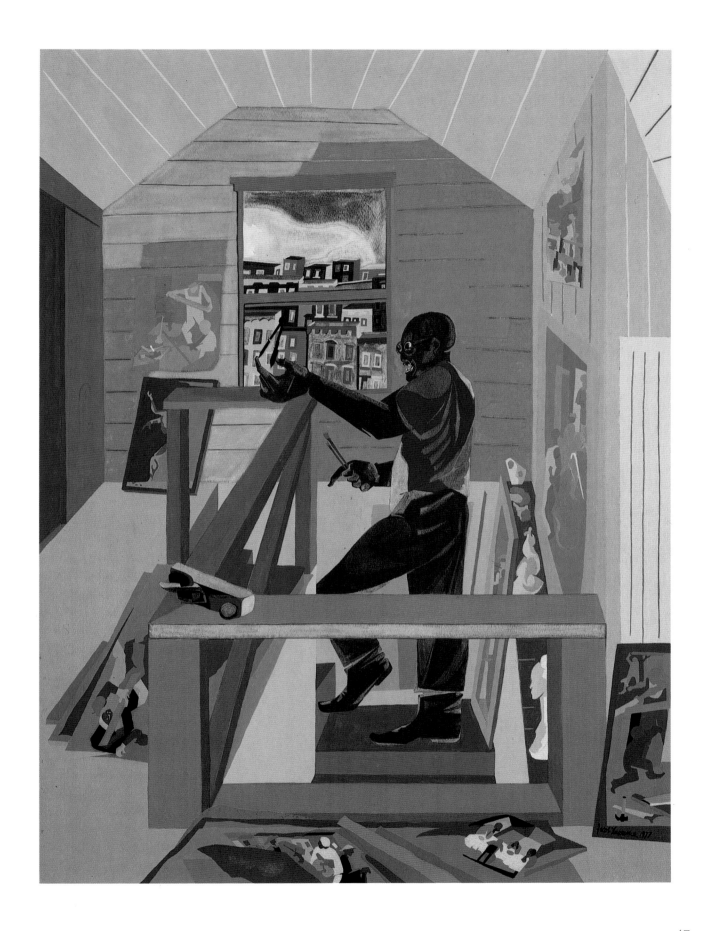

WE ARE ALL LIGHT AND ENERGY, 1981

Audrey Flack, American (born 1931), acrylic and oil on canvas, 46" x 66"

*A*s a child, Audrey Flack preferred drawing and painting to academic subjects. With her father's encouragement, Flack began her formal training at New York City's High School of Music and Art, a public school for gifted young artists and musicians.

In the 1960s, Flack examined the different ways that light gives objects their color and *form*. She observed that under extremely bright artificial light, ordinary objects were magically transformed. They seemed larger, more colorful, and even more three-dimensional than they actually were.

Flack's self-portrait with her parrot Alfred makes us think about the line separating reality and illusion. The painting, which is about four times larger than life size, has the clarity and intense color of the high-definition images we see on television and in glossy magazines today. The illusion is shattered only when we notice the bare *canvas* beneath the shadow of her necklaces and realize that this is a painting, not a photograph.

Flack created fine gradations of color using a mechanical tool called an airbrush. For the face, she applied lighter and darker hues over a medium skin tone to shape the *contours*. Because an airbrush breaks paint into tiny particles, the colors underneath gleam through to create the effect of light shining from within. She added laser-sharp *highlights* that create a halo effect using interference paint, which contains tiny particles of mica, a transparent mineral that reflects light. The vaporous *background*, thickly painted with palette knives and brushes, emphasizes the sharp details in the portrait.

Flack's super-realist paintings anticipated today's fascination with high-definition computer images that are brighter and sharper than real life.

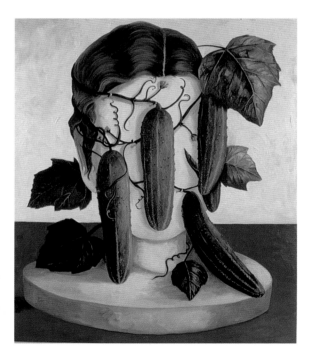

New York-based artist Cheryl Laemmle formed her features and hair with vegetables and weeds in a humorous painting that recalls the work of Salvador Dalí.

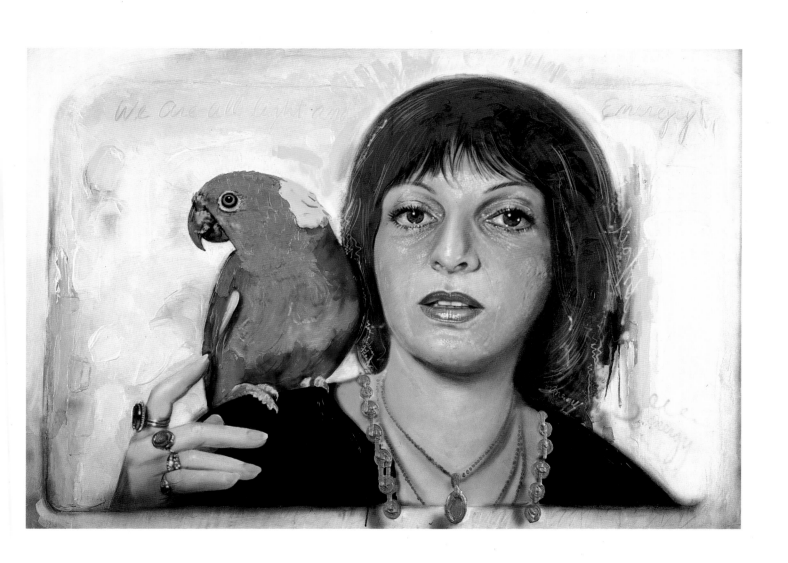

Glossary and Index

ABSTRACT, 36: Having form and color but not recognizable subject matter.
ACRYLIC PAINT, 44: See PAINT
Artist and His Mother, The, 37
Art of Painting, The, 17

BACKGROUND, 12, 16, 22, 24, 30, 34, 38, 40, 44: The part of a painting behind the subject; the distant area. *See also* FOREGROUND
Beckmann, Max, 34
Bronzino, Agnolo, 12

CANVAS, 28, 30, 44: A woven fabric (often linen or cotton) used as a painting surface. It is usually stretched tight and stapled onto a wooden frame in order to produce a flat, unwrinkled surface.
Chagall, Marc, 30
CLASSICAL, 12: A term that refers to paintings and sculpture created by artists who admire and adopt the art of ancient Greece and Rome.
COLOR, as it is used by painters, is identified by three different terms. The actual appearance of the color (red, blue, bluish green, etc.) is its *hue*. Everyday words can be used to describe a hue that occurs in nature, such as rose, sky blue, and grass green.
 A lighter or darker version of a hue, created by adding white or black, is called a *shade*.
 A hue that is changed by adding a small amount of another color is a *tint*. For example, a painter might add a small amount of red to gray, to yellow, and to blue and create reddish tints of these original colors.
COMPOSITION, 12, 20, 40. *See also* DESIGN
CONTOUR, 8, 20, 24, 38, 44: An outline or the suggestion of an outline, especially of an irregular shape.
CONTRAST, 18, 30, 34, 36, 40: Big differences in light and dark, shapes, colors, and activity.

DESIGN, 20: (1) The arrangement of objects and figures in a painting through the combination of colors and shapes. This is also called *composition*. (2) A decorative pattern of shapes, such as leaves.
Dix, Otto, 28
Double Portrait with Wine Glass, 31
DRAWING, 10, 14: The art of creating an image by making marks on paper. Drawings can be made using dry materials such as pencil, charcoal, and crayon or wet materials such as ink and paint. Drawings may consist of lines, tones, shading, and dots. Twentieth-century artists began to create drawings that are difficult to distinguish from paintings. An important difference is that drawings are usually on paper rather than canvas, wood, or metal. Drawings produced with more than one kind of material are known as mixed-media drawings.
Dürer, Albrecht, 8

Ensor, James, 22
Ernst, Max, 32
Evergood, Philip, 38

Flack, Audrey, 44
FOREGROUND, 32: The area in a painting closest to the viewer. *See also* BACKGROUND
FORM, 26, 40, 44: All of the qualities that uniquely describe a person or object, including size, weight, color, shape, texture, tone, and movement.

Gogh, Vincent van, 22 (Pronounced van Go)
Gorky, Arshile, 36

HIGHLIGHT, 8, 18, 20, 30, 34, 42, 44: The lightest color or brightest white in a painting.

Kahlo, Frida, 40

Labille-Guiard, Adélaïde, 18
Lawrence, Jacob, 42
Leonardo da Vinci, 10
LINE, 8, 10, 24, 26, 38: A mark, such as a pencil mark, that does not include gradual shades or tones.

Mother Antony's Tavern, 21
MURAL, 12: A very large painting that decorates a wall or is created as part of a wall. Also called a wall painting.

OPAQUE, 28: Not letting light pass through. Opaque paints conceal what is under them. (The opposite of TRANSPARENT)

PAINT: Artists have used different kinds of paint, depending on the materials that were available to them and the effects they wished to produce in their work.
Different kinds of paint are similar in the way they are made.
1. Paint is made by combining finely powdered pigment with a vehicle. A vehicle is a fluid that evenly disperses the color. The kind of vehicle used sometimes gives the paint its name, for example: oil paint. Pigment is the raw material that gives paint its color. Pigments can be made from natural minerals and from chemical compounds.
2. Paint is made thinner or thicker with a substance called a medium, which can produce a consistency like that of water or mayonnaise or peanut butter.
3. A solvent must be used by the painter to clean the paint from brushes, tools, and the hands. The solvent must be appropriate for the composition of the paint.
ACRYLIC PAINT, 44: Pigment is combined with an acrylic polymer vehicle that is created in a laboratory. By itself, acrylic paint dries rapidly. Several different mediums can be used with acrylic paint: retarders slow the drying process, flow extenders thin the paint, an impasto medium thickens the paint, a gloss medium makes it shiny, a matte medium makes it dull.
 Acrylic paint has been popular since the 1960s. Many artists like its versatility and the wide range of colors available. Acrylic paint is also appreciated because its solvent is water, which is nonhazardous.
OIL PAINT, 12, 14, 18, 20, 22, 24, 26, 28, 30, 32, 34, 36, 40, 44: Pigment is combined with an oil vehicle (usually linseed or poppy oil). The medium chosen by most artists is linseed oil; the solvent is turpentine. Oil paint is never mixed with water. Oils dry slowly, enabling the artist to work on a painting for a long time. Some painters add other materials, such as pumice powder or marble dust, to produce thick layers of color. Oil paint has been used since the fifteenth century. Until the early nineteenth century, artists or their assistants ground the pigment and combined the ingredients of paint in their studios. When the flexible tin tube (like a toothpaste tube) was invented in 1840, paint made by art suppliers became available.

WATERCOLOR, 42: Pigment is combined with gum arabic, a water-based vehicle. Water is both the medium and the solvent. Watercolor paint now comes ready to use in tubes (moist) or in cakes (dry). Watercolor paint is thinned with water, and areas of paper are often left uncovered to produce highlights.

Gouache is an opaque form of watercolor, which is also called tempera or body color.

Watercolor paint was first used 37,000 years ago by cave dwellers who created the first wall paintings.

PALETTE, 16, 24: (1) A flat tray used by a painter for laying out and mixing colors. (2) The range of colors selected by a painter for a work.

PATRON, 12, 14: An individual or organization that supports the arts or an individual artist.

PERSPECTIVE, 16, 32: Perspective is a method of representing people, places, and things in a painting or drawing to make them appear solid or three-dimensional rather than flat. Six basic rules of perspective are used in Western art.

1. People in a painting appear larger when near and gradually become smaller as they get farther away.
2. People in the foreground overlap people or objects behind them.
3. People become closer together as they get farther away.
4. People in the distance are closer to the top of the picture than those in the foreground.
5. Colors are brighter and shadows are stronger in the foreground. Colors and shadows are paler and softer in the background. This technique is often called *atmospheric perspective*.
6. Lines that in real life are parallel (such as the line of a ceiling and the line of a floor) are drawn at an angle, and the lines meet at the *horizon line*, which represents the eye level of the artist and the viewer.

In addition, a special technique of perspective, called *foreshortening*, is used to compensate for distortion in figures and objects painted on a flat surface. For example, an artist will paint the hand of an outstretched arm larger than it is in proportion to the arm, which becomes smaller as it recedes toward the shoulder. This correction, necessary in a picture using perspective, is automatically made by the human eye observing a scene in life. *Foreshortening* refers to the representation of figures or objects, whereas *perspective* refers to the representation of a scene or a space.

Painters have used these methods to depict objects in space since the fifteenth century. However, many twentieth-century artists choose not to use perspective. An artist might emphasize colors, lines, or shapes to express an idea instead of showing people or objects in a realistic space.

Picasso, Pablo, 26

PORTRAIT, 7, 8, 12, 18, 20, 26, 30, 32, 36, 38: A painting, drawing, sculpture, or photograph that represents an individual's appearance and, usually, his or her personality.

Portrait of a Young Man, 13
Portrait of the Artist Holding a Thistle, 11

Rembrandt Harmenz van Rijn, 14
Renoir, Pierre-Auguste, 20 (Pronounced Ruhn-wahr)

SELF-PORTRAIT: A painting of the artist by the artist. *See also* PORTRAIT
Self-portrait, 11, 15, 29
Self-portrait in a Flowered Hat, 23

Self-portrait in Tuxedo, 35
Self-portrait with a Beer Stein, 39
Self-portrait with a Palette, 27
Self-portrait with Monkey, 41
Self-portrait with Straw Hat, 25
Self-portrait with Two Pupils, 19

SHADING, 8, 10, 18, 42: The use of gradually darker and lighter colors to make an object appear solid and three-dimensional.

SHADOW, 10, 14, 20, 22, 34, 36: An area made darker than its surroundings because direct light does not reach it.

SILHOUETTE, 30, 36: An image, such as a portrait or an object, that consists of the outline of its shape in a solid color.

Studio, The, 43

TEXTURE, 14, 24, 30, 38, 40: The surface quality of a painting. For example, an oil painting could have a thin, smooth surface texture, or a thick, rough surface texture.

TONE, 14, 16, 18, 20, 24: The sensation of an overall coloration in a painting. For example, an artist might begin by painting the entire picture in shades of greenish gray. After more colors are applied using transparent glazes, shadows, and highlights, the mass of greenish gray color underneath will show through and create an even tone, or *tonal harmony*.

Painters working with opaque colors can achieve the same effect by adding one color, such as green, to every other color on their palette. This makes all of the colors seem more alike, or harmonious. The effect of tonal harmony is part of the artist's vision and begins with the first brushstrokes. It cannot be added to a finished painting. *See also* COLOR

TRANSPARENT, 8, 24, 28, 38: Allowing light to pass through so colors underneath can be seen. (The opposite of OPAQUE)

TURPENTINE, 18: A strong-smelling solvent made from pine sap, used in oil painting. (*See also* PAINT; OIL PAINT)

Vermeer, Jan, 16

We Are All Light and Energy, 45
Where Friends Meet, 33

Credits

Frontispiece
THE PAINTER AND THE CRITIC, Date unknown
Pieter Brueghel, Dutch
Graphische Sammlung, Albertina, Vienna

Page
9 *PORTRAIT OF THE ARTIST HOLDING A THISTLE*
 Albrecht Dürer, German
 Musée de Louvre, Paris
 © Photograph R.M.N.

10 *SELF-PORTRAIT*, c.1485
 Filippino Lippi, Italian
 Fresco on flat tile, 19¾" x 12¼"
 Uffizi Gallery, Florence

11 *SELF-PORTRAIT*, c. 1514
 Leonardo da Vinci, Italian
 Royal Library, Turin

12 *SELF-PORTRAIT*, c. 1575
 Guiseppe Arcimboldo, Italian
 Pen and blue pencil on paper, 9¼" x 6¼"
 Národni Gallery, Prague

13 *PORTRAIT OF A YOUNG MAN*
 Bronzino,(Angolo di Cosimo di Mariano), Italian
 The Metropolitan Museum of Art, New York
 Bequest of Mrs. H.O. Havermeyer, 1929.
 The H.O. Havermeyer Collection, (29.100.16.)

14 *SELF-PORTRAIT*, c. 1655
 Rembrandt Harmanzoon van Rijn, Dutch
 Pen and brown ink, 8⅛" x 5⅝"
 Rijksprentenkabinet, Amsterdam

15 *SELF-PORTRAIT*, 1629
 Rembrandt Hermanzoon van Rijn, Dutch
 Mauritshuis, The Hague

16 *SELF-PORTRAIT AT THE AGE OF FORTY-FIVE*, 1542–43
 Hans Holbein the Younger, Dutch
 Black and colored chalks on pink-tinted paper, 9" x 7"
 Uffizi Gallery, Florence

17 *THE ART OF PAINTING*, c. 1665
 Johannes van Delft Vermeer, Dutch
 Kunsthistorisches Museum, Vienna

19 *SELF-PORTRAIT WITH TWO PUPILS*, 1785
 Adélaïde Labille-Guiard, French
 The Metropolitan Museum of Art, New York
 Gift of Julia A. Berwind, 1953. (53.225.5.)

20 *PORTRAIT OF THE ARTIST OR THE DESPERATE MAN*, c. 1843
 Gustave Courbet, French
 Oil on canvas, 17¾" x 21¼"
 Private Collection

21 *MOTHER ANTONY'S TAVERN*
 Pierre-Auguste Renoir, French
 National Museum, Stockholm, Sweden

23 *ENSOR WITH FLOWERED HAT*, 1883
 James Ensor, Belgian
 Stedelijke Musea and Stadsarchief Oostende, Belgium

24 *PORTRAIT OF THE ARTIST, DEDICATED TO HIS FRIEND DANIEL*, 1896
 Paul Gauguin, French
 Oil on canvas, 16" x 12½"
 Musée d'Orsay, Paris

25 *SELF-PORTRAIT WITH STRAW HAT*
 Vincent van Gogh, Dutch
 © The Metropolitan Museum of Art, New York
 Bequest Adelaide Milton de Groot (1876–1967), 1967.
 (67.187.70a.)

27 *SELF-PORTRAIT WITH A PALETTE*, 1906
 Pablo Picasso, Spanish
 Philadelphia Museum of Art, Philadelphia, Pennsylvania
 The A.E. Gallatin Collection

29 *SELF-PORTRAIT*, 1912
 Otto Dix, German
 © The Detroit Institute of Arts
 Gift of Robert H. Tannahill

31 *DOUBLE PORTRAIT WITH WINE GLASS*, 1917
 Marc Chagall, Russian
 Musée National d'Art Moderne, Paris, (AM 2774 P)

33 *THE RENDEZVOUS OF FRIENDS*, 1922
 Max Ernst, German
 Rheinisches Bildarchiv
 Museum Ludwig, Köln

34 *SELF-PORTRAIT WITH FISHING POLE*
 Max Beckmann, German
 Pen and ink with pencil indications on paper, 23½" x 17¾"
 The University of Michigan Museum of Art, Ann Arbor, Michigan
 (1950/1.159.)

35 *SELF-PORTRAIT IN TUXEDO*, 1927
 Max Beckmann, German
 Courtesy of the Busch-Reisinger Museum
 Harvard University Art Museums, Museum Association Fund

37 *THE ARTIST AND HIS MOTHER*
 Arshile Gorky, Russian
 Collection of Whitney Museum of Art
 Gift of Julien Levy for Maro and Natasha Gorky in memory of their father. (50.17.)

38 *SELF-PORTRAIT WITH HAT*, 1961
 Philip Evergood, American
 Lithograph, 26" x 19"
 Courtesy Terry Dintenfass Gallery, New York

39 *SELF-PORTRAIT WITH A BEER STEIN*, c. 1935
 Philip Evergood, American
 Mixed media on gesso paper, 16" x 12"
 Private collection
 Courtesy Midtown Payson Gallery

40 *SELF-PORTRAIT*, 1949
 Diego Rivera, Mexican
 Tempera on linen, 12¼" x 9⅞"
 Private collection
 Courtesy Mary-Anne Martin/Fine Art, New York

41 *SELF-PORTRAIT WITH MONKEY*, 1938
 Frida Kahlo, Mexican
 Allbright-Knox Art Gallery, Buffalo, New York
 Bequest of A. Conger Goodyear, 1966.

42 *ME: 1940 AND 1990*, 1990
 Paul Cadmus, American
 Crayons on grey paper, 9¾" x 9⅝"
 Courtesy Midtown Payson Gallery

43 *THE STUDIO*, 1977
 Jacob Lawrence, American
 Seattle Art Museum, Seattle,Washington. Gift of Gull Industries;
 John H. and Ann H. Hauberg; Links, Seattle; and by exchange from
 the estate of Mark Tobey. © Jacob Lawrence/VAGA New York 1993

44 *SELF-PORTRAIT AS A MAN WITH CUCUMBERS*, 1990
 Cheryl Laemmle, American
 Oil on canvas, 90" x 68"
 Courtesy Terry Dintenfass Gallery, New York

45 *WE ARE ALL LIGHT AND ENERGY*, 1981
 Audrey Flack, American
 Courtesy Louis K. Meisel Gallery, New York
 Photo by Steve Lopez